V. Wallace

# How to Start printmaking

# How to
# Start printmaking

Gerry Downes

Photographs by Graham Murrel

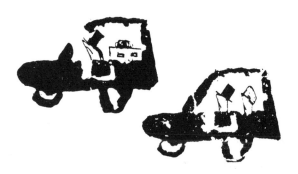

Studio Vista　London

# Acknowledgements

The author thanks Dorothy and Dorothea for
invaluable help with the manuscript; and
Michael and Maureen who inspired many of the prints

Printed in England by
Shenval Press, London and Harlow
Published in Great Britain by
Studio Vista Publishers
Blue Star House, Highgate Hill, London N19

ISBN 0 289 70364 6

# Contents

# Introduction

Printmaking means making pictures by printing on paper or cloth or any other material.

The prints illustrated in this book need no special equipment beyond ink and rollers and knives and simple tools. They were printed from odds and ends found around the house and in friends' attics and cellars.

A good print, like many good things, is easily recognised but it is impossible to describe what is good about it. The success of your prints will depend on your own artistic judgement. It does not matter in the least whether they are abstracts or pure designs or represent something recognisable. You will probably find that your best prints are the ones you enjoyed printing most.

It is always best to learn all the rules first; once they have been learned, you can take even greater pleasure in breaking them. Do not rush too much. Learn to handle small things and simple combinations first and the bigger, more complex prints will seem easier. Do not limit yourself to what can be called strictly a print. Many well-known artists finish off their prints by adding handdrawn bits.

Just as you will experiment with the things you print, try a wide range of materials to print *on*. You will get a lovely effect by printing on sacking, plastic, polythene, patterned paper, or printed pages from books and magazines.

Read through the sections on tools and materials (pages 7–9) and the hints on page 66 before you start.

# Materials

**You can print on almost anything:**
newspaper
colour magazines
pages from old books
wrapping paper
carrier bags
paper bags
cardboard boxes
ends of wallpaper rolls (both sides)
rolls of lining paper (from wallpaper shops)
writing paper
typing paper, bank or bond (from stationery shops)
cartridge paper (or strong drawing paper)
sugar paper (or construction paper)
postcards
paper napkins

**You can print on cloth:**
handkerchiefs
shirts
smocks
vests
clean rag
jeans
shorts
scarves

**Here are some things you will need to make prints:**
(*You will need only one or two of these things for each print*)
water-based printing ink (from artist's suppliers)
inking rollers
Stanley knife or other craft knife (with heavy-duty blade)
lino cutting tools
sheet of glass or metal plate for an ink-palette
acrylic or poster paint or ordinary household paint
office inking pads (see page 10 for making your own)
lots of newspaper
an old sheet or blanket for padding
two drawing boards or
    two sheets of hardboard about 60 × 90cm (2 × 3ft)
one or two heavy books
fabric dye or paste (Rowney make a suitable one)
burnishing pad (a newspaper ball with one smoothed side)
plenty of clean rag or tissues for cleaning up
turpentine or white spirit for paint or oil-based inks

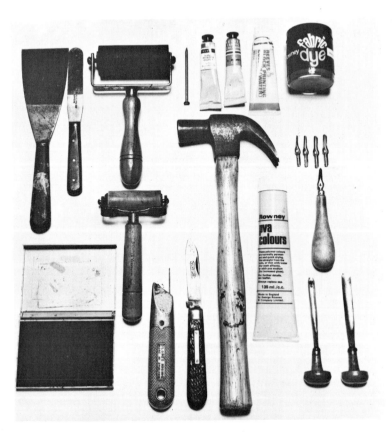

## Here are some things you can print from:

feathers
brooches
combs
scissors
brushes
staples
paper clips

plasticine
biscuits (colour photograph page 34)
toys
gloves
sponges (colour photograph page 34)
paper doylies

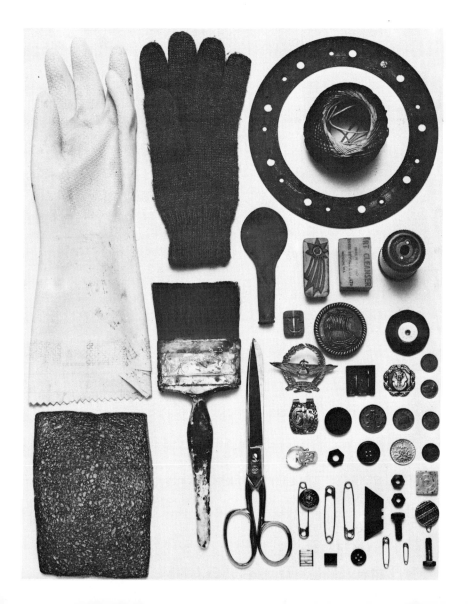

# Printing with your hands

### Fingers and thumbs
You need:

an office printing pad in red, black, blue or green (see below for making your own)

paper (any kind will do. Try 'bank' paper for really crisp results or make some greetings cards using blank postcards)

ballpoint or felt-tipped pen

*Making a printing pad*
You can make your own pad very easily by wrapping a piece of sponge in cloth and stuffing it very tightly into an old tin or plastic box. The sponge must be larger than the tin.

Soak it with fountain-pen ink.

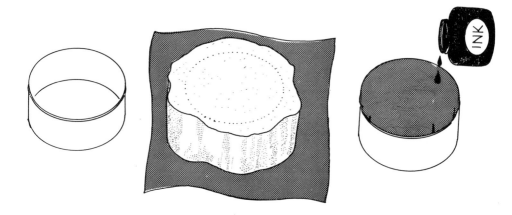

At first a home made pad may seem too squashy and may over-ink. Allow it to dry a little before you use it and, most important of all, remember to pack the sponge in really tightly to start with.

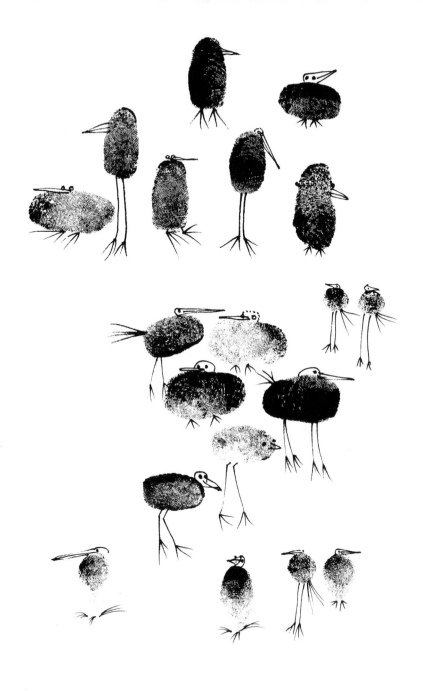

*These birds are made from a whole series of finger and thumb prints*

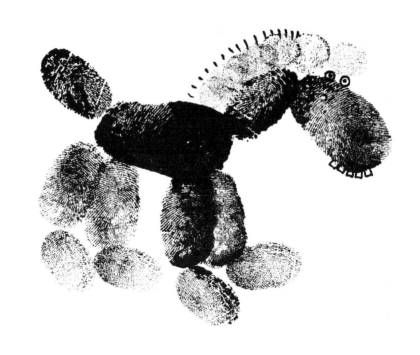

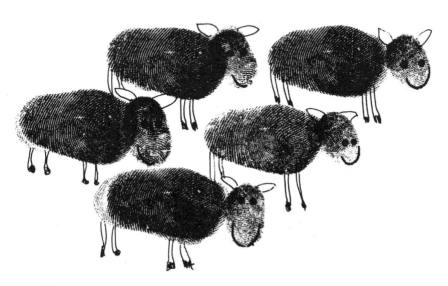

Press your fingers on the pad and then press them firmly on the paper. Once you have found out how to make a clear print, try some variations. The 'Horse with furry trousers' opposite was made in several colours.

If you make multi-coloured prints, clean your fingers well before you change colours, or use different fingers for each colour, or the pads will get very dirty.

Use ballpoint of felt-tipped pen to finish off the details like the legs and ears on the sheep on the facing page.

## How to fake footprints

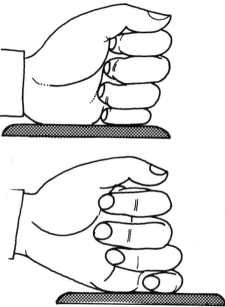

Press the side of your clenched fist on the ink pad. Press the inked fist, still clenched, on the printing paper. Now ink your fingertips and add some toes (see page 14).

To make smaller feet, crook your little finger and carefully press just the side of that finger on the ink pad. Press it, still crooked, on the paper and add toes of fingerprints.

If you buy some lino printing ink and a roller, you can use the roller to ink your fingers and hand. Squeeze out two or three inches of ink onto a piece of glass and roll it out to an area of about four inches square. Dab your fingers in the ink, taking care not to slide them. Alternatively, roll the inky roller up your hand and fingers.

You can use poster or acrylic paint, but it tends to dry rather quickly.

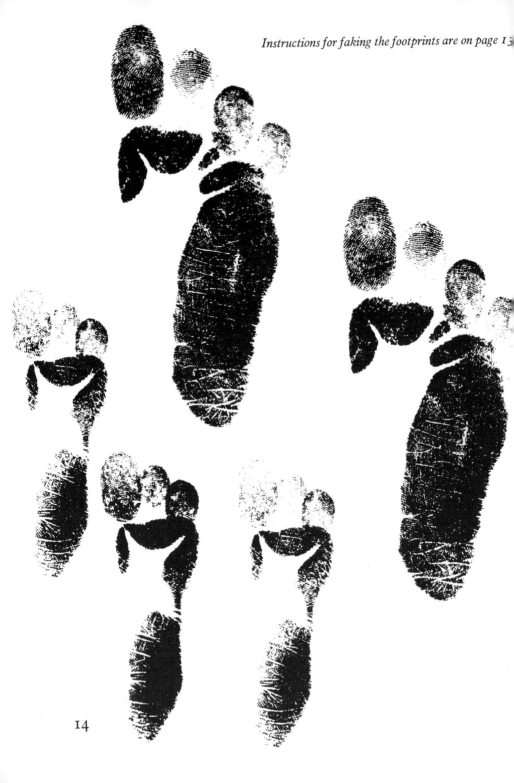

*Instructions for faking the footprints are on page 13*

14

## Funny men and monsters

Crook your little finger again.
This time press the whole
side of your hand and finger
on the pad. Press it on paper.
It will make a monster's leg.

Clench your fist and press
the knuckles on the pad.
Print this, then add odd prints
of parts of your fingers and
hands. Use more than one
colour for best effects. You
can make some very weird
beasts this way.

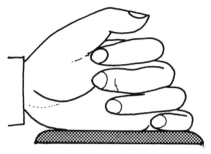

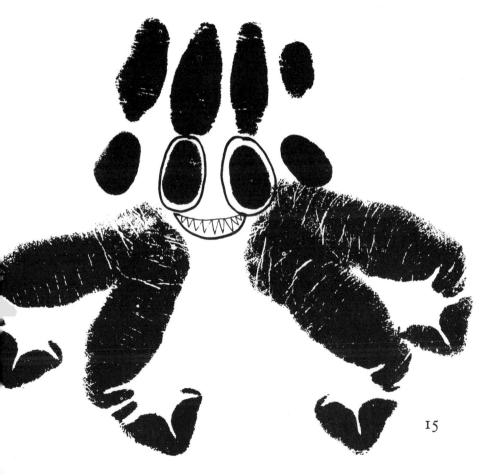

15

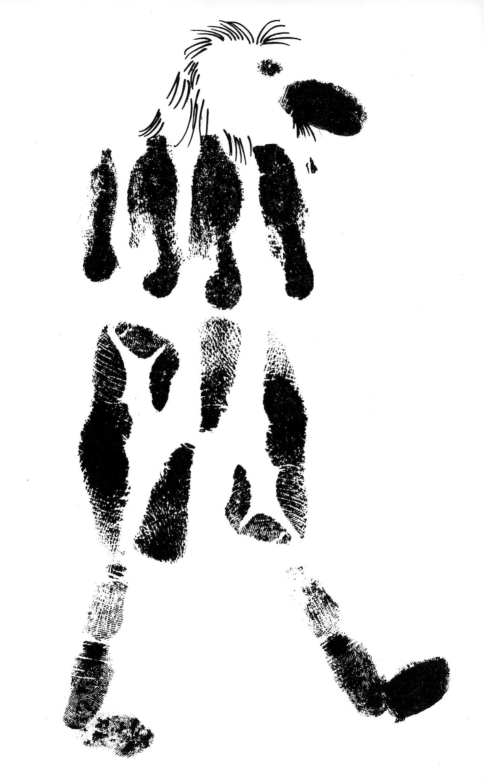

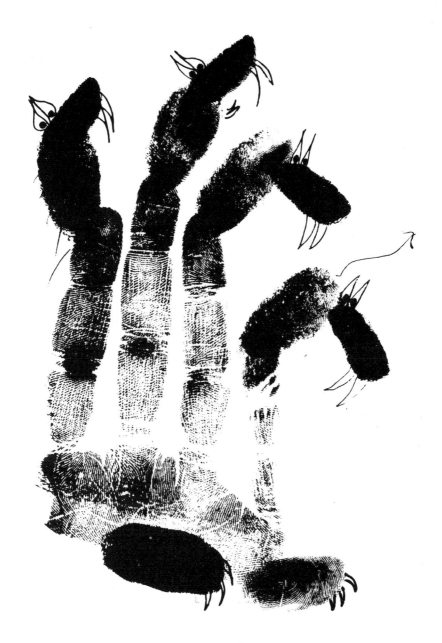

The ogre opposite and the hydra above are all made up of
fingers and thumbs. Details were added with a ball-point
pen.

# Printing with bits and pieces

You can produce some nice effects by printing things like these:

coins
buttons
indiarubbers
brooches
tin or plastic lids
felt-tipped pens (these often have shaped ends)
pencil sharpeners
paper clips
anything with an embossed or engraved pattern

Using your ink pads, try a few prints to see the effect. Simply press the object onto the ink pad and then onto the paper.
Brooches that have reasonably flat surfaces will print well on paper, but buttons with crests or deeply embossed designs are best printed on cloth laid on a pad of cloth to provide some 'give'. Small buttons or coins can be fixed to the end of a fat pencil with double-sided adhesive tape.

Try decorating paper napkins (good for parties) or handkerchiefs (good for presents).

On the facing page are an engine and some funny men made up of a whole assortment of odds and ends. There are two more in colour on the cover. The figure in 'A walk in the park' on page 20 was printed from an old brooch.

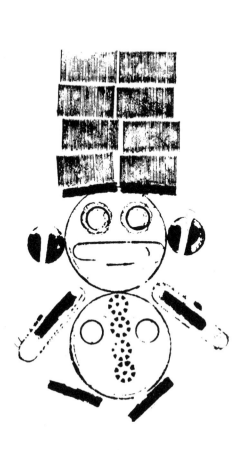

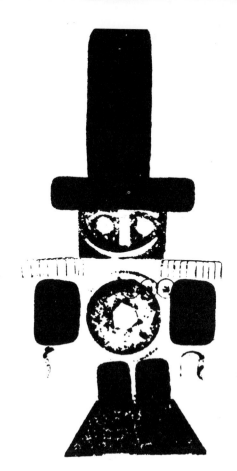

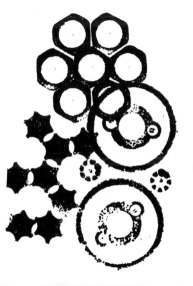

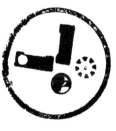

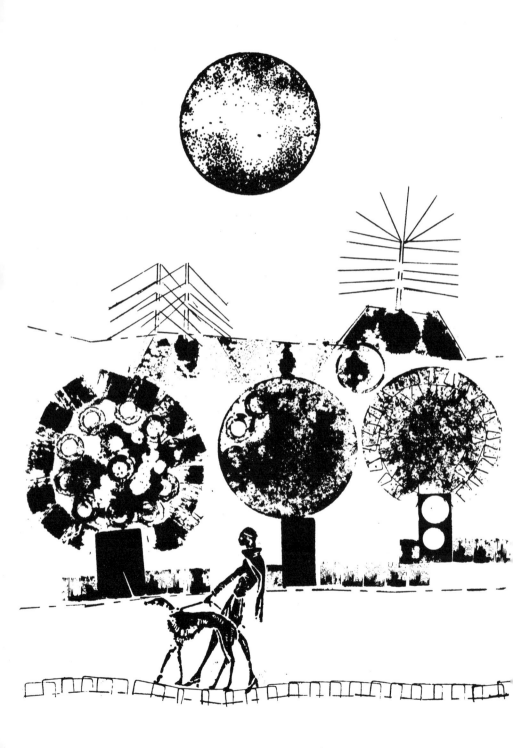

**Funny faces**

You need:
ink pads or printing ink
several indiarubbers or erasers
paper or card for printing on
Stanley knife or other sharp knife

Cut one of your indiarubbers in two so as to have a smooth surface for working on. Use your knife to cut a face. Make holes for the eyes, nose and mouth, but do not make them too deep. Take a print.

Now cut a slice off the rubber block about 6mm ($\frac{1}{4}$in) thick with the face on it. Put this on one side.

On the new, smooth surface cut another design, perhaps a hat, and add it to the first print.

Now cut a body on another rubber block and print it as before. Keep going until you have made the whole figure.

The advantage of these small blocks is that you can place the different pieces together very carefully and exactly to build up quite complicated designs.

The king on page 22 was built up with rubber block prints in this way. So were the angry man and totem pole on page 23.

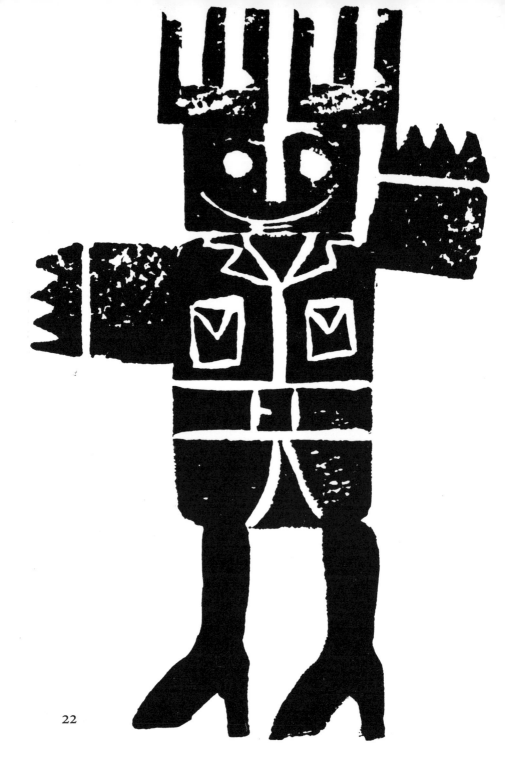

This king, the bad-tempered man and the totem pole were all made up from india-rubber cuts.

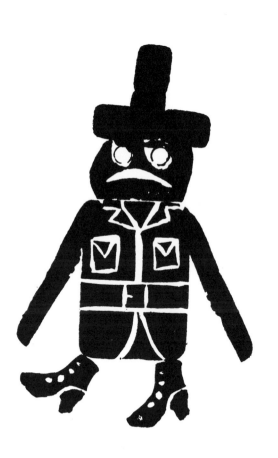
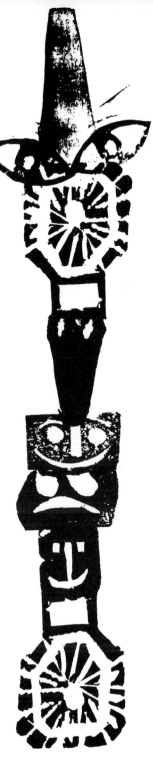

## Geometric patterns

You can ink these rubber blocks with the ink pad, but use printing ink in order to extend your range of colours. Do not press too hard either when inking or printing or the blocks will skid.

Try cutting a simple geometric pattern and printing a repeat pattern like one of those on the facing page. Cut your initial and use this for a repeat pattern or to sign your prints with.

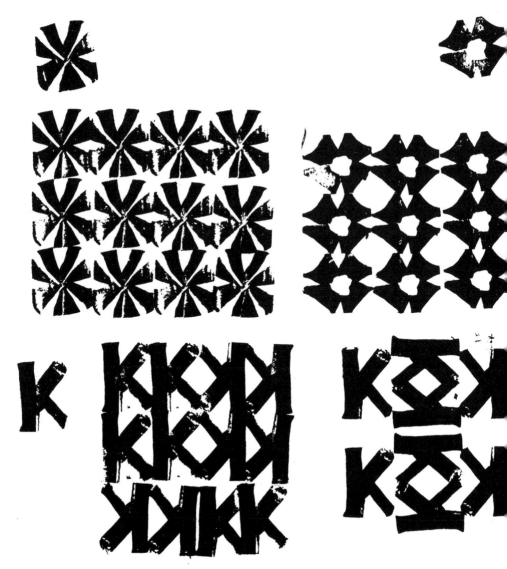

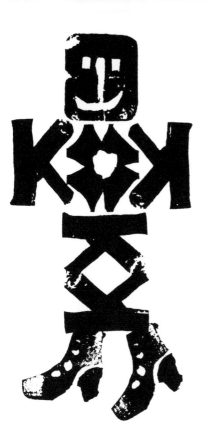

As you become more skilful at cutting the rubber, you will be able to cut ever more complex designs. You could cut lots of different animal or human faces and bodies and make hilariously funny hybrid beasts.

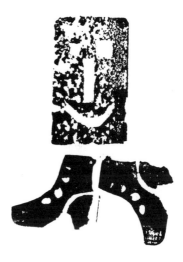

Try these:
cats
birds
flowers
trees
houses
cars and lorries
spiders
hands
eyes

## Comical combinations

Cut an eye in your rubber block. The same block can be used for both eyes. Then cut a mouth, then a nose. Use these three elements and change their position. By having the eyes close together or wide apart and the mouth crooked or upside down you can create quite different characters. (See page 28.)

Make a composite block like this:
There are six sides on an indiarubber. On one of them cut a face, on another a hat. On the largest side cut a body and on the other sides arms and legs.

Six-sided blocks need to be handled very carefully. You will otherwise end up with ink on every finger and fingerprints where you do not want them on the print.

With care you can print an army of soldiers or a football team.

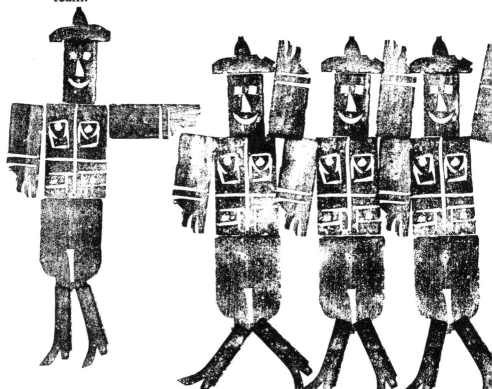

These are two six-sided rubber blocks.

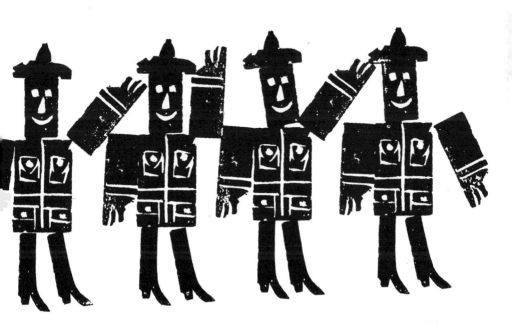

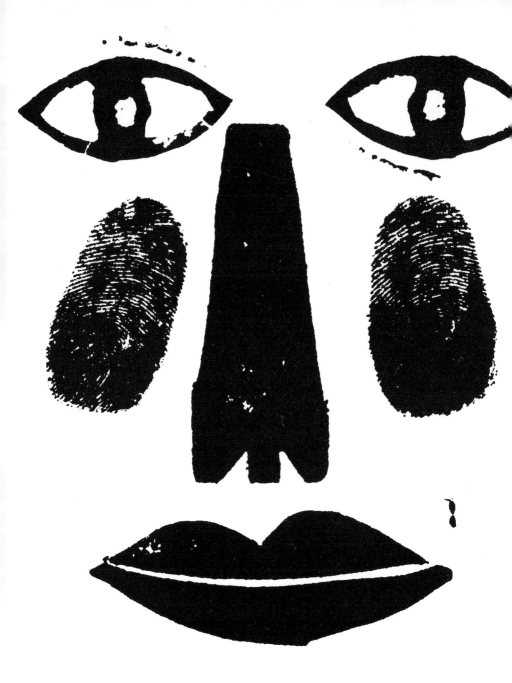

This face was printed with rubber blocks and fingerprints.

# Greetings cards and gifts

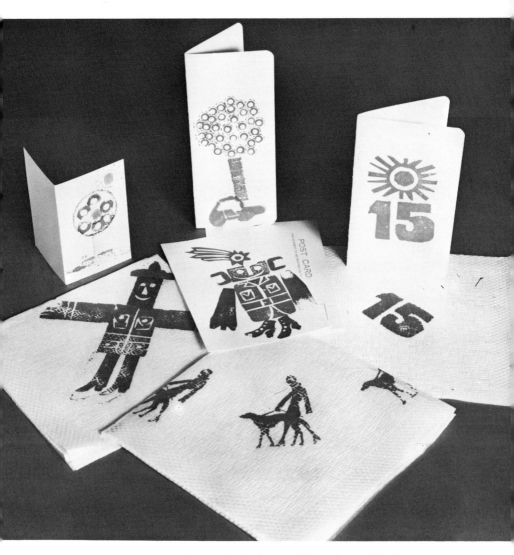

You can see that this method, in combination with the use of buttons and brooches (see page 18), can be used for making landscapes and city scapes.

Here are several gifts and prints you could try.

# Inking up junk

To do these objects and textures justice, you must use printing ink or acrylic paint. Since many of the prints will be quite large, you will need to organise your working method carefully (see hints on page 66).

You need:
ink
rollers
palette
printing paper. This could be lining paper, wallpaper, newspaper, cartridge or sugar paper
two drawing boards or two sheets of hardboard, one to put down to make a firm, flat surface (the base board) and one to act as a pressure plate
a couple of heavy books

A selection of things to print:
woollen glove
rubber glove
combs
balloons
feathers
biscuits
a sponge
leaves
tools
paint brushes (opposite)
polystyrene packaging
some old iron and builder's plaster board
string
(The prints on pages 32, 33, 34, 37, 47, 48 and 49 all used at least one of these things.)

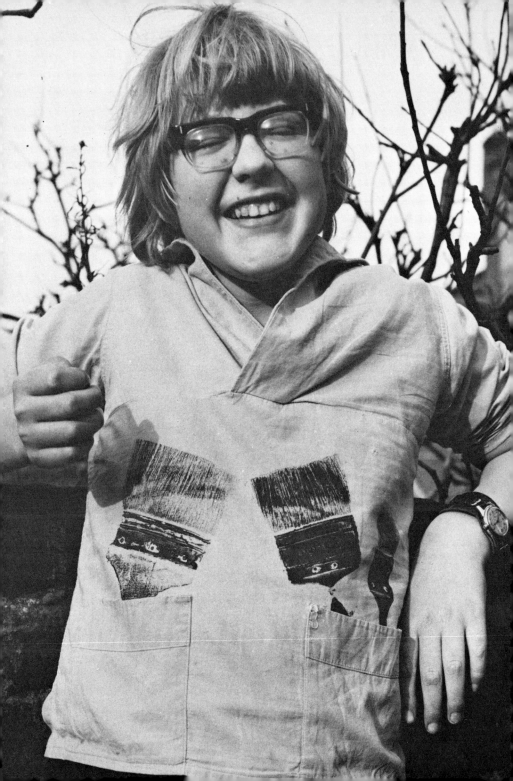

## Hardware

This is how to print such things as tools (see the pliers on the cover) and paintbrushes like those on the painter's smock on page 31.

Put down your baseboard with a folded cloth on top to provide some 'give'. Lay a sheet of paper on the baseboard and lay the inked object face down on top. Cover it with some newspaper, put the pressure plate on top, and stand on it. Remove the layers carefully to avoid smudging.

You may occasionally find that it is best to put the paper on last, in which case you would put the inked object face up on the baseboard.

You could try dipping string in paint, coiling it onto the paper and printing it as above.

*How many objects can you recognise in the picture opposite? This abstract design is inside printed outlines made with polystyrene packaging*

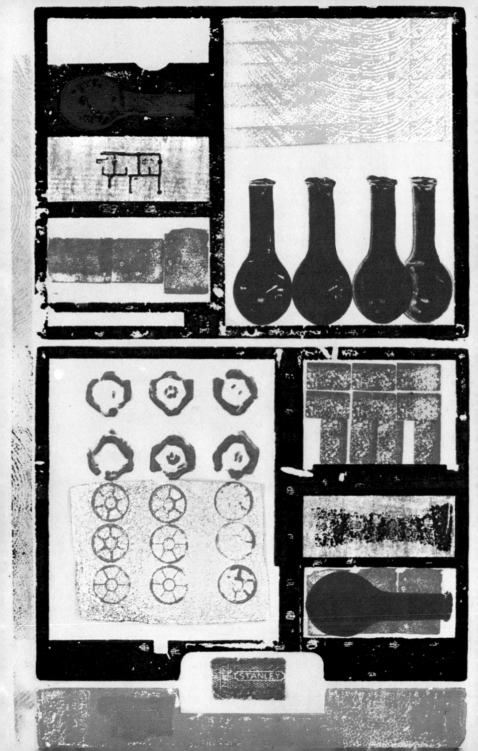

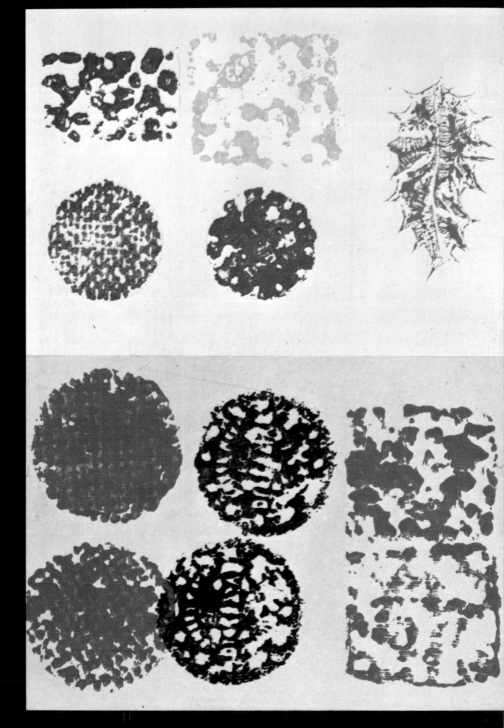

**Software**
Use this method for things like:
gloves
balloons (see page 33)
feathers
leaves

Roll out an area of ink larger than the object you want to print. Lay the object in the ink, cover it with a sheet of newspaper and put a heavy book on top. Lean on it to press the object well onto the ink.

Put a pad of newspaper or pad of cloth on the baseboard. Put down the printing paper and carefully lay the inked object on it. Cover it with newspaper. Put the pressure plate on top and stand on it.

Even quite difficult things like the holly leaf opposite can be printed in this way.

If you try balloons, blow one up first and let it down again to get a nice wrinkly print.

Opposite: *A large selection of prints from 'software'. The square objects are sponges and the round ones biscuits*

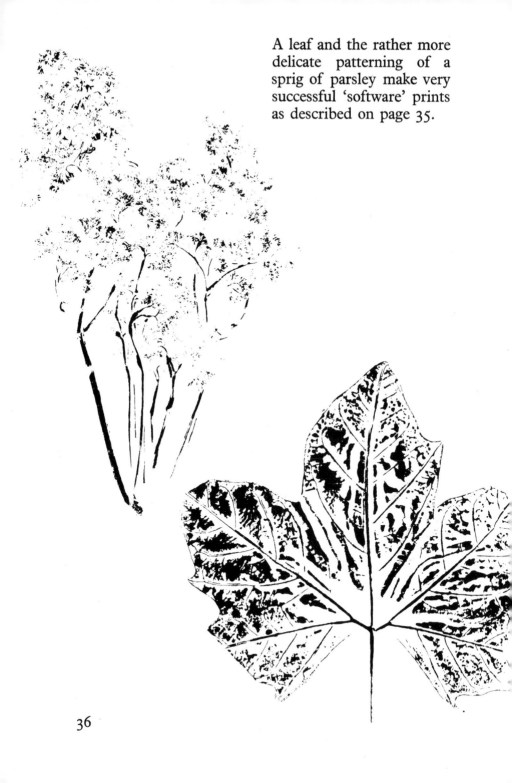

A leaf and the rather more delicate patterning of a sprig of parsley make very successful 'software' prints as described on page 35.

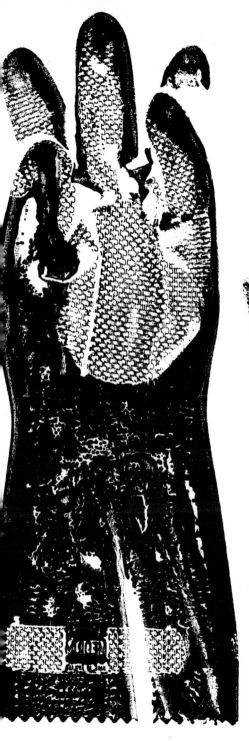

And there are no prizes for guessing what was used to make the prints on this page!

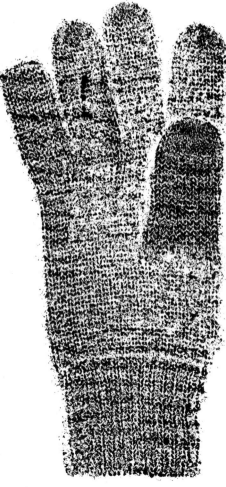

37

## Collage pudding

Still using the odds and ends
you have found, stick them
down into a card or wooden
base to make a relief print.

Try to choose oddments of
the same thickness. Use:
paper clips
coins
nails
lollipop sticks
straws
cocktail sticks
nuts (the kind that go with bolts)

Use glue or double-sided
sticky tape to stick them down.

Try sticking down several
strips of double-sided
adhesive tape and coiling
string onto it to make abstract
designs or perhaps initials
(see page 40). This is a very
good way of making initials
for handkerchiefs or scarves.

Make a block by folding up
paper and sticking the layers
together. Cut shapes from
corrugated card and stick
them down too. Several of
the designs illustrated were
printed from plasticine stuck
to a paper block with double-
sided adhesive tape.

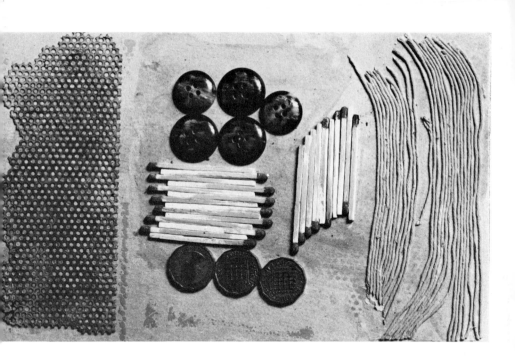

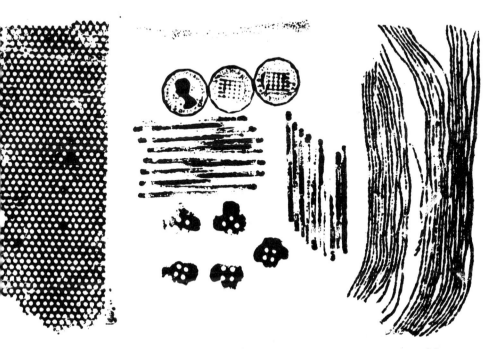

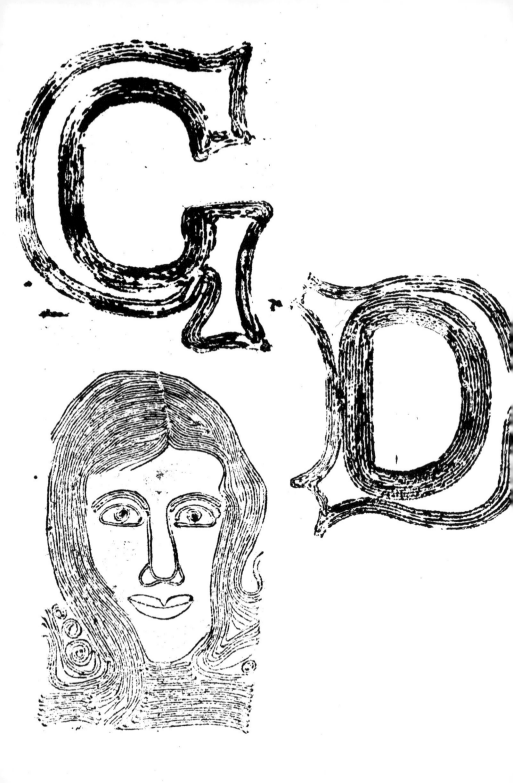

On pages 38 and 39 are two kinds of 'collage puddings' made from string, coins, matchsticks, buttons and pieces of old junk.

The face and initials on the facing page were printed from string coiled onto paper blocks covered with double-sided adhesive tape.

The prints on this page are made from plasticine with its ribbed markings still on it. To make the top print a pair of scissors was pressed onto the plasticine and carefully lifted out again before the block was printed.

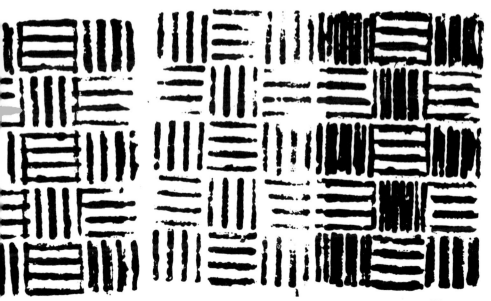

# Cutting, scratching and hammering

Now try to create designs that are entirely your own. To do this you will need more tools and a variety of materials to work in.

You need:
several pieces of hardboard (or Masonite)
some card
soft wood
linoleum
vinyl tiles
Stanley knife with heavy-duty blade
hammer and nails; a gimlet or bradawl; a saw

First, look at the back of a piece of hardboard. You can make a lovely print from that woven texture. Using your knife, cut some areas away by scoring round them and levering out the centre shapes. This is called layering, because the hardboard strips off in layers.

Make simple strong designs; it is quite hard work.

The same technique can be worked on the shiny side of the hardboard, but this time cut and scratch textures with a gimlet around the shapes you have made. Make background textures in hardboard or vinyl or linoleum by punching holes with a hammer and nail.

You can buy cheap sets of lino-cutting tools from artists' stores, but try using the knife and hammer and nail as well.

On the facing page the same 'layered' design was printed twice in different colours and made deliberately out of register.

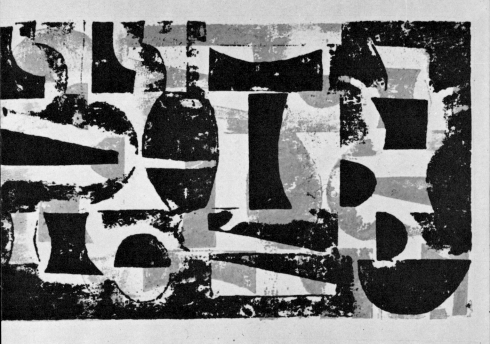
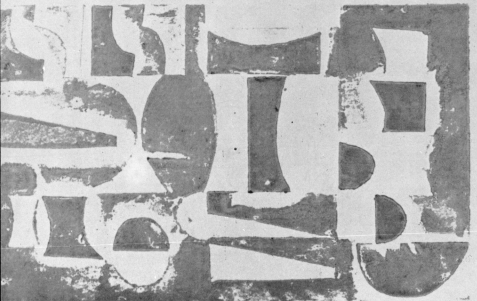

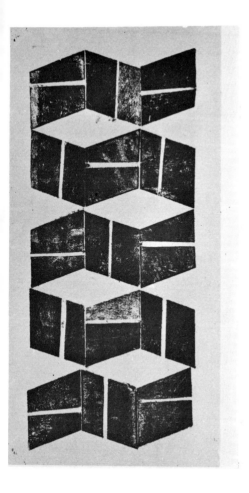
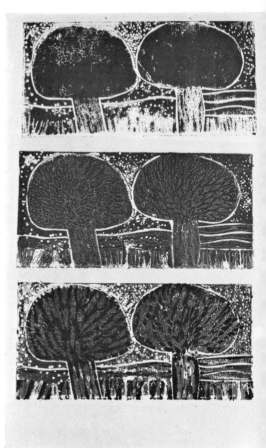

The print on the left was made from a layered cardboard block. The one on the right was printed according to the cut-and-come-again method described on page 53.

The prints on the facing page were made on newspaper (top) and tissue paper.

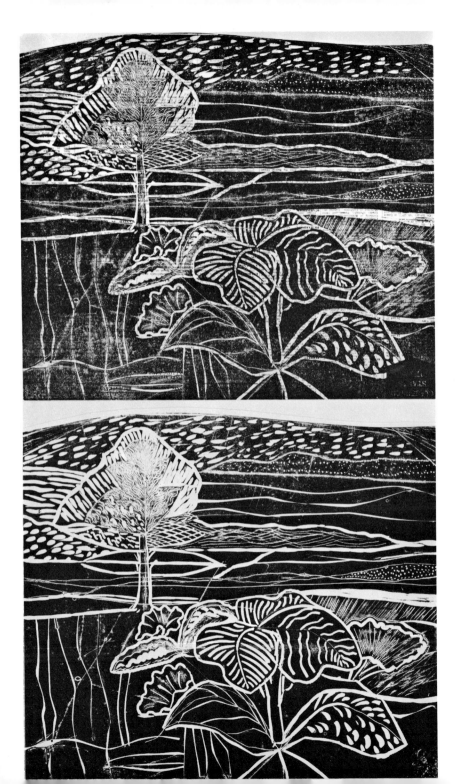

# Colour Printing

One way of making a colour print is to print in one colour on a different coloured paper. Try printing black on yellow or red paper; but try also printing red on red or blue on blue, and even black on black. The gloves opposite were printed in red on blue paper.

If you use shiny coloured papers you will get an interesting contrast between the shiny surfaces and the rather matt ink.

You need:
several coloured inks (red, yellow, blue. These are called the primary colours because most other colours can be mixed from them)
coloured paper

Printing more than one colour in a design means that you have to 'register' the colours. This means you have to make sure they fit together properly.

For your first experiments, use some of the blocks or objects you have used before. For example, ink up the back of a piece of hardboard in yellow. Take several prints to allow for spoilage – perhaps a dozen. Leave them to dry for half an hour. Now take another block or an article such as a glove and overprint it in red on the yellow.

Strictly speaking, you should allow each colour to dry completely before you print another on it, though interesting effects come from overprinting on wet inks. If you use more than three colours, or are printing large areas requiring a lot of ink, it is best to be patient and allow time for drying.

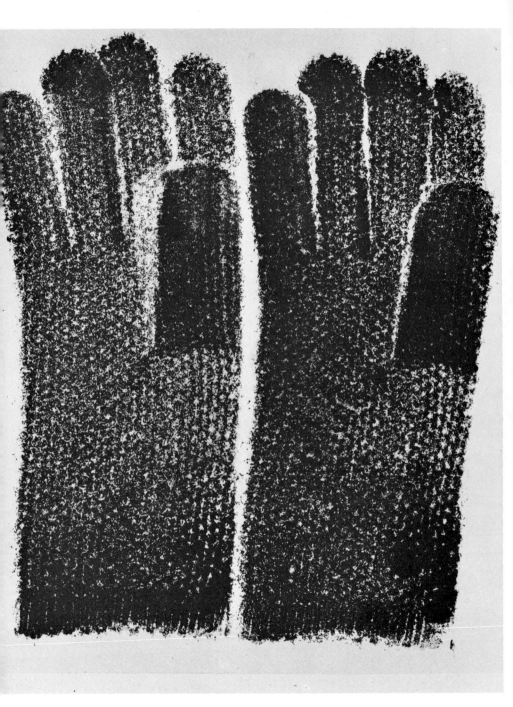

To make a print from string, simply dip it in paint, coil it onto the paper and lay your sheet of scrap paper and a board on top. Here the string was overprinted on another colour on a design made up from a piece of perforated metal, a sponge and a building block.

The tools opposite were all printed in different colours.

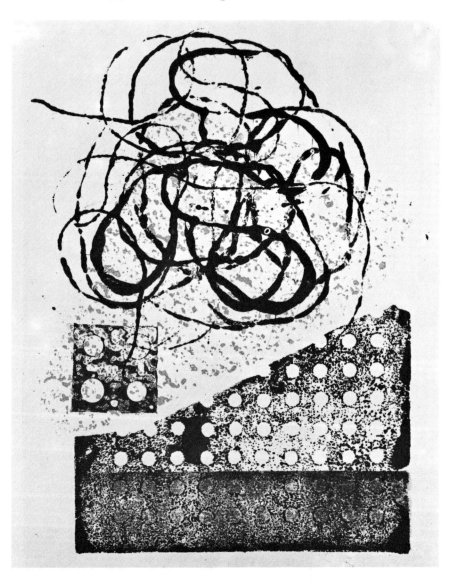

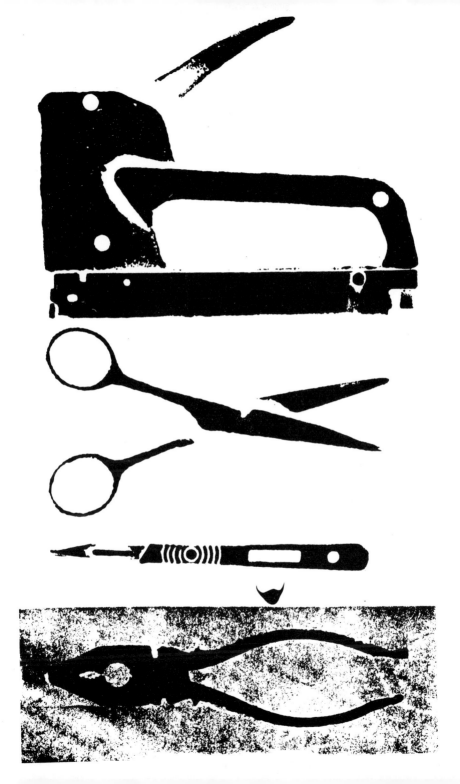

**Ripping up**

Here is a method of achieving multi-coloured prints by printing in just one colour.

You need:
coloured paper (some coloured papers are sold with ready-gummed backs)
coloured tissue paper
Cow gum or other rubberised adhesive

Print your design in black or another strong colour on several coloured papers. When the prints are dry, tear them up in uneven strips and paste them onto one complete print or onto white paper. Because the image is the same, you will be able to fit up the strips quite accurately.

Good results come from using coloured tissues since they are transparent and each colour affects all the others.

Cow gum or any other rubberised adhesive is best for pasting up since it does not wrinkle the prints. It is also possible to buy a special adhesive for tissue paper.

The fish on the facing page were all printed from the same vinyl block using this method.

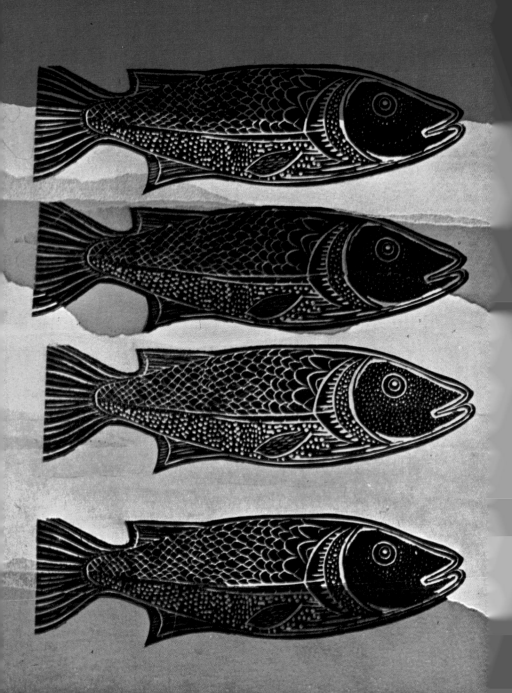

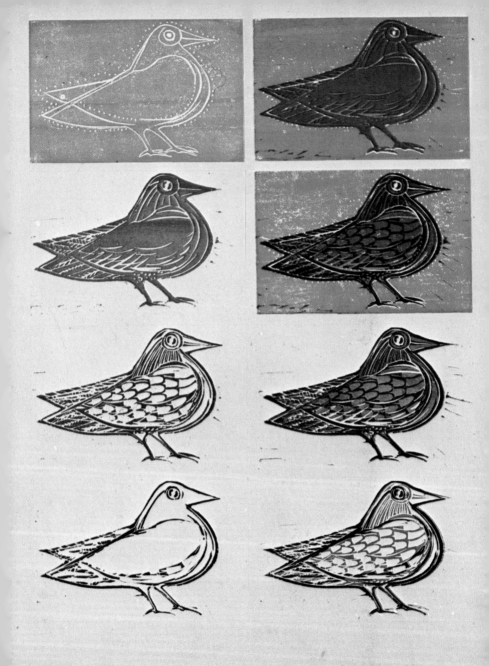

## Cut-and-come-again

The most interesting use of overprinting is mixing two colours to create a third. Just as in mixing paints, printing red on yellow can give orange; blue on yellow can give green; blue on red can give purple.

Here is a good system that does not have too many problems of register, or positioning one print exactly on top of another.

Cut a few basic shapes from hardboard, lino or card and print them in yellow. Take lots of prints as you will not be able to print the same design again. Clean the block and modify the design by cutting away some more from it. Use it to overprint the yellow prints in blue. Because you are printing from the same block you should find it fairly easy to register the prints accurately. Clean the block and modify the design by cutting away some more, and print it in black over the blue.

Look at the photograph on the facing page.

The prints in the left-hand column are made from the same block in its four stages of development. The orange print was made from the first cut. Then more cuts were added to make the blue print. In the top right-hand corner is the blue print overprinted on the orange. Then more cuts were added to the block to make the brown print, which was overprinted on the blue and orange.

The black print is the same block which has been cut further, and the other prints are different combinations of overprinting.

# Fabric printing

You can try printing on fabric any of the larger objects so far mentioned in this book.

You need:
padding on your baseboard
acrylic paint
printing ink (water-based ink is not washable, so use an oil-based ink)
paint

The paint brushes on page 31 were printed in this way:
Place a smock or shirt on the padded baseboard.
Ink up the brushes one at a time.
Place them so that the handles are in the pockets.
Lay a sheet of newspaper and then the pressure plate on top and stand on it.
Take the pressure plate and newspaper away carefully. Lift the brushes carefully one by one.

Try printing on:
aprons
shirts (simple designs on the pockets or sleeves)
jeans (simple designs on the pockets or round the bottom of the legs).

The shirt with the glove design on the facing page was printed using this method.

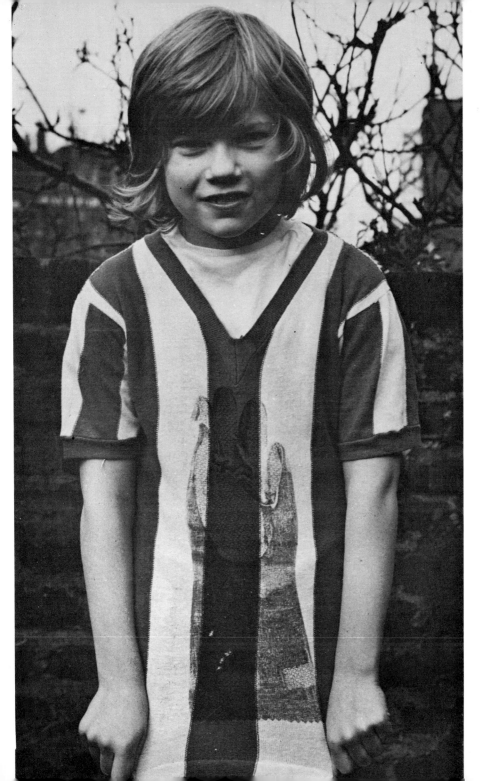

## Using fabric dye

The little boy on the facing page was printed from a wood block. Any soft wood can be used, but try to get a flat piece with a good grain. He was drawn by drawing around a tin lid to make his face and body.

The design was cut using a Stanley knife sloping the blade in from two directions so as to make v-section cuts. If you have any chisels or wood working tools, make use of them. The background was made with a hammer and nail.

Damp the block with a sponge and brush on the dye with a soft brush. Place the fabric to be printed on the padded baseboard and then place the block on top. Use the pressure board in the usual way.

You can also use fabric paste which, like the dye, comes in all colours. Unlike the dye it can be applied with a roller just like ink.

When completely dry, these dyes can be fixed by ironing the back of the design with a warm iron. But before this, put several layers of paper inside any garment so the paint does not go through to the other side. Also have a sheet of paper between the garment and the iron.

If you work with acrylic paint, you can colour each part of the design differently and print a multi-coloured design in one printing. Keep the paint fairly thin, and brush it on as evenly as possible.

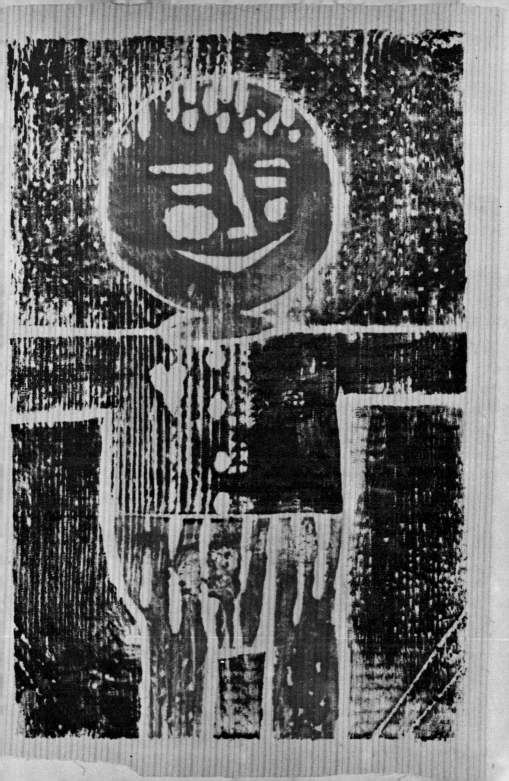

## Fruit and vegetables

Acrylic paint is particularly good for printing fruit or vegetables on fabric.

Cut an apple carefully in half, making sure that you end up with a flat surface. Brush on the paint and print it on cloth or even on absorbent paper such as soft drawing or sugar (construction) paper.

Try using carrots, onions, cabbages or tomatoes. Print them onto handkerchiefs or paper napkins (see facing page) for presents or party table decorations.

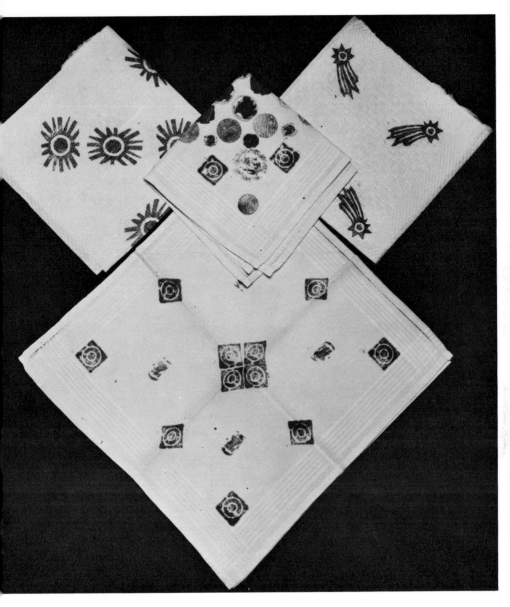

These paper napkins were printed with rubber cuts, coins and buttons.

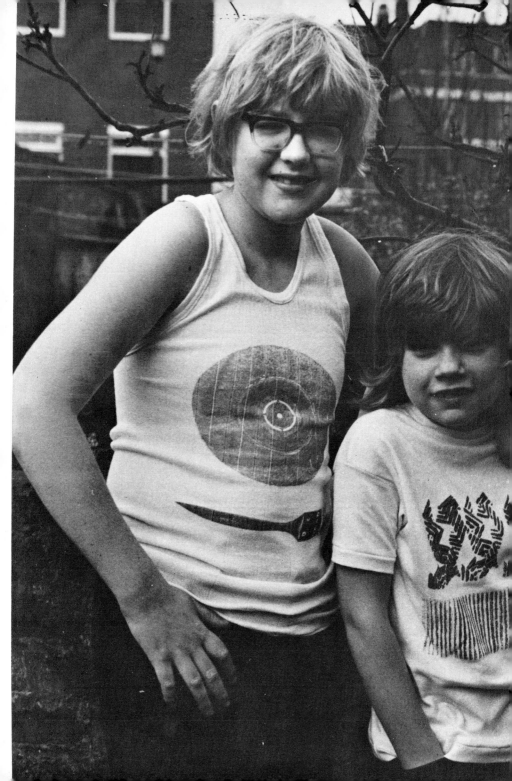

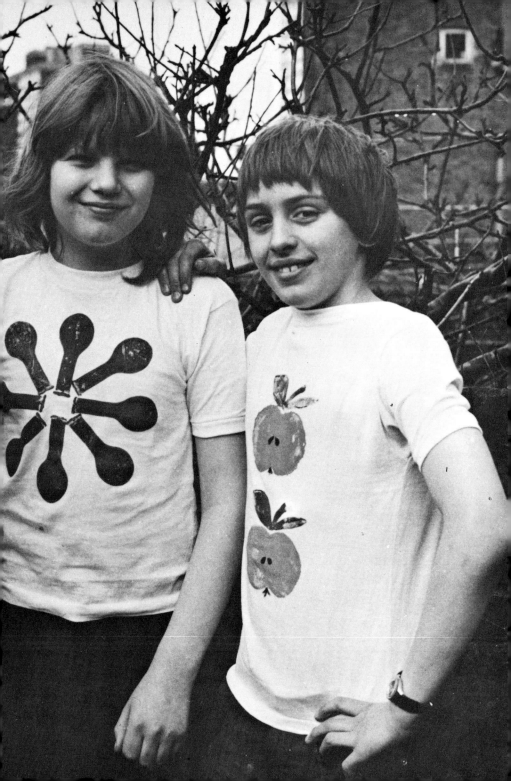

**Paint your pistol**
This is a bit messy, so prepare yourself with:
lots of newspaper on the floor and table
turpentine or white spirit
plenty of rag for cleaning up
brushes
paint (ordinary household or acrylic)

You have to print on cloth and you will need fairly large pieces (old sheets?) and possibly some help.

Cover something like the toy pistol, opposite, with the paint. Be careful not to smudge it; and clean your hands regularly or you will get dirty fingerprints on your print. Spread newspapers on the floor and spread the fabric out on it. Put the painted object on the cloth a little below the centre. Fold the cloth over it from top to bottom. Cover it with another piece of cloth and press down carefully. Unwrap the cloth and remove the object. You will have printed both sides and the top.

This is a tricky thing to manage alone, and a helping hand from a friend is essential. The biggest danger is smudging as you press. Try to press firmly without moving the cloth too much.

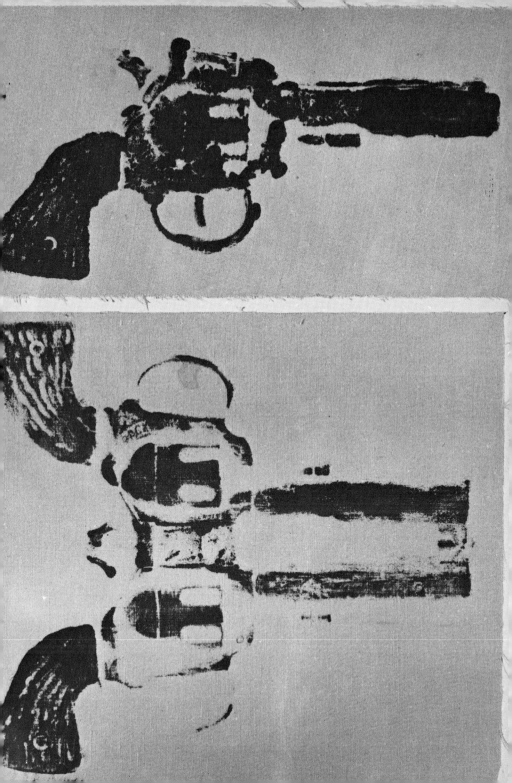

# Printing paintings on glass

This is a technique called 'monoprint' and is a favourite technique among artists. Many famous painters, among them Degas and Monet, used it a great deal.

All you do is paint a design or image on a sheet of glass. Use oil paint, fabric dye, or acrylic paint. Lay a sheet of paper on the wet painting and lay a pad of newspaper on top of that. Press on it gently.

You get beautiful pale colours and every brush stroke is reproduced faithfully.

Try painting simple signs or symbols and heraldic devices and print them on tee-shirts. The target design opposite and the apples on the tee-shirt on page 61 were printed this way using acrylic paints.

For excellent personal presents, you could paint someone's portrait or that of their favourite pop star or footballer and print it on a tee-shirt or handerkerchief.

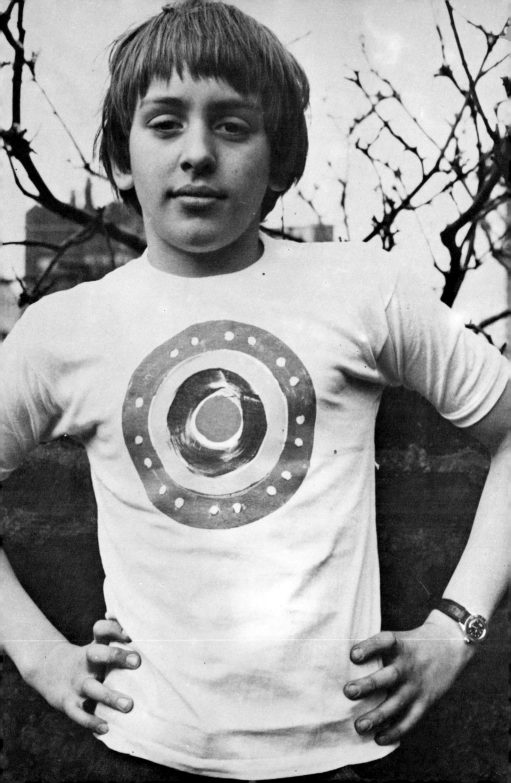

# Hints

*Fabric dye* can be mixed together to make other colours, so do not spend a great deal of money buying colours unnecessarily. You could mix most of the colours you will want from a basic set of primaries (yellow, red and blue) and only buy very special extra colours as you find you need them.

Dye can be thinned with medium and fabric ink can be thinned with extender paste.

When fixing these colours by ironing, remember to do it on the back and through a sheet of paper.

When printing shirts, put some newspaper inside to stop the dye going through to the back of the garment.

*Double-sided tape* is best for making string blocks when you want a controlled design, but a glue such as Evostick or Bostick works very well for abstract designs where the string is 'dribbled' onto the block.

*To dry prints* use french chalk or artists' fixative, or make a drying line from a length of string. Attach the prints to it with spring clip pegs or bulldog clips.

*Inking biscuits* is simpler if you use a palette knife to spread the dye or acrylic paint like butter. Do not fill the holes in the biscuits.

*Inking card.* Do not be surprised if, when inking up card relief blocks, you find the card 'layering' by itself. Pick the pieces off the roller and print where they have come loose. You will get some surprise effects.

# Suppliers

Reeves and Sons Limited and George Rowney and Company Limited supply artists' shops everywhere. They make lino-cutting tools, rollers, water-based inks (called 'Block Printing Ink' by Reeves and 'Lino Ink' by Rowney). Rowney sell Fabric Dye in pots and Reeves sell Fabric Ink in tubes. Both companies make excellent goods and you should experiment with both until you find which satisfy you best.

T. N. Lawrence and Son, 4 Bleeding Hart Yard, Greville Street, London EC1, sell absolutely everything for printmakers.
Woolworths are good for indiarubbers, postcards, paperclips and cheap but good stationery. Watch out for bargain-sized packs of paper napkins.

All art shops have stocks of plain and coloured paper. (See the yellow pages of the telephone directory for your local shops.) For a really exciting choice of papers try:
Paperchase Products Ltd, 216 Tottenham Court Road, London W1, and F. G. Kettle, 127 High Holborn, London WC1, for marvellous coloured tissues, metallic papers and fine hand-made or Japanese papers. Lining paper, bought by the roll from Do-it-yourself shops or decorators' shops, is very good value and useful for experiments.

# Index